"Reading *Women in the Middle,* written like holding up a mirror. Each chapte sight that one in this age group can r sees this stage as entering new territoi en are well-equipped to handle its new challenges by the learning they have accumulated. She helps older women to give themselves a little self-applause, while cheering them on to continue the journey of life without faint heart. And everything she shares is punctuated at the end with an appropriate prayer. This is a gem of a book, like a visit from a friend."

Antoinette Bosco
Author, *The Pummeled Heart*

"In *Women in the Middle,* Margot Hover takes us for a walk through mid-life, a gentle walk, where one come to terms with 'what is.' At a time when our physical eyes begin to diminish, our spiritual eyes develop nearly perfect vision, as she observes. 'There's something about middle age that sensitizes our sight to the tiny threads in life's fabric.'

"Hover's style is relaxed and comforting. If you're 'in the middle,' you'll likely recognize yourself in many of these reflections."

Judy Esway
Author, *Letting Go, Reflections and Prayers for Mid-Life*

"Margaret Hover presents us with wonderful new snapshots of familiar stories. She captures moments of life that are both worth remembering and capturing as the real triumphs of being a 'middle' woman. These reflections are born of her awareness and sensitivity to Scripture and the wisdom of her own prayer life. Her prayers give glimpses of her own deep and living faith.

"For all of us facing the wonders and pains of middle life, *Women in the Middle* will encourage us to remember our own life stories and to use it as a model for our own expression."

Agnes M. Barry
Carolinas Medical Center

"Margot Hover has made a unique and rejuvenating contribution to the area of women's spirituality. While many women in mid-life feel burdened with regrets, self-doubt, and low self-esteem, Dr. Hover has lifted up the wisdom of this stage of life to celebrate its joys, its accomplishments, and its freedoms. She has revealed in this work the sacred dimension of feminine experience in ways that are often overlooked or undervalued. Those women who accept her invitation to delve honestly into their own stories will find her example a source of inspiration and authentic spiritual renewal."

Nancy Ferree-Clark, Pastor
Congregation at Duke University Chapel

"The brief stories, reflections, and prayers in this book should comfort many people startled to find themselves middle-aged. Dr. Hover does a good job of explaining the benefits of the central portion of our passage from youth to old age. With experience, we can judge better what is important and what not. We can also be more tolerant of others and ourselves. Our parents can come into better focus, as we realize how much they put up with in rearing us. We can see in our children the energy and presumption of youth, now less prominent in our own bodies and psyches.

"Middle age can be a depressing time, more slough than peaks or even valleys. We can feel that we are just plodding along. *Women in the Middle* shows both women and men other ways to think about ordinary days—ways encouraging, even redemptive. Dr. Hover is a good guru for all those caught in the middle, far from youth, yet not quite ready for retirement and veneration."

Denise Lardner Carmody
Santa Clara University

Women in the MIDDLE

Facing Midlife Challenges with Faith

Margot Hover

TWENTY-THIRD PUBLICATIONS
Mystic, CT 06355

Twenty-Third Publications
185 Willow Street
P.O. Box 180
Mystic, CT 06355
(203) 536-2611
800-321-0411

ISBN 0-89622-612-3
Library of Congress Catalog Card Number 94-60480
Printed in the U.S.A.

Contents

Introduction

I'm sure you've seen that bumper sticker, "Youth is wasted on the young," bemoaning the apparent mismatch of stamina and naivete. However you feel about that, middle age is definitely not wasted on the middle aged. Middle age brings the convergence of life experience and wisdom with the ability to use our energies well.

Middle age confronts us with the results and consequences of decisions made years before. In fact, in middle age, we get our "second wind," as many of us change careers and lifestyles. This stage of life is different from youth, however. By middle age, our hopefulness is tempered with realism. Our parents have actually grown old; when we were young, they merely seemed old to us. With the sensitivity born of our own age and life experience, we become aware of their fragility and mortality. As we help them to adapt to old age, we begin to think of our own old age.

Meanwhile, our children, in their youthful idealism, look at us and vow to live their lives differently. By middle age, we look at our parents in old age and death, and are more realistic about their gifts and strengths, more open to the lessons they offer to us, more appreciative of the choices they made and the obstacles they've overcome.

As middle-aged women, caring for our bodies has a different meaning than it had when we were younger. Then, we paid attention to skin care, nutrition, and exercise with high

value on attractiveness. Women in middle age are confronted with the physical consequences of neglect; we think warily about skin cancer, osteoporosis, and heart disease as well as aging beautifully. Some women experienced their monthly cycle as uncomfortable and annoying, while others saw it as affirming their health and womanliness. Either way, menopause leads us to conscious awareness that life changes irrevocably in middle age.

Middle age brings us to a deeper realization of life-as-process. The designation, "middle-aged" itself implies that one is between, on the way from one stage to another. But in middle age, we're inclined to be more accepting of where we are, less consumed with being somewhere else. Ten, twenty, thirty years ago, our focus was on "when" and "as soon as": "When I get married . . . " "When I finish school . . . " "As soon as the children are older. . . ."

Now we're there. And while there are goals to be reached, corners to be turned, and wishes to be fulfilled, we are more patient now. We give ourselves time. And we want to enjoy the process as well as the end result. We are less inclined to put the rest of our lives on hold while we concentrate single-mindedly on one end point. Earlier, we may have been able to keep all the juggling balls in the air, as the saying goes. Now, we don't mind letting some fall, and we are wiser about the ones that do.

But there is a kind of ambivalence that comes with this stage of life. While we acknowledge that middle age and the perspective that comes with it take half a lifetime to reach, we nevertheless sometimes wish that we had gotten here earlier. For instance, as my daughter carefully explains to me that she will be a different parent than I was, I value at last my mother's patience when I enacted a similar rite of passage with her.

And I wish I had acquired this perspective then.

Fortunately, one of the fruits of middle age is a growing ability to ask forgiveness of others, and to forgive ourselves as well. In middle age, I tell my daughter that I am sorry for my impatience and for my part in the misunderstandings she remembers. Any younger, my outward defensiveness would have prohibited this kind of communication, while my inner drive to be the perfect parent would have overwhelmed me with a sense of failure.

If youth could be said in any way to be "wasted on the young," middle age is certainly wasted on the fainthearted. And I, for one, am often fainthearted. In reflecting on my middle age journey thus far, it strikes me that I would miss so much of the good of this part of life were it not for my faith and my community of friends and neighbors. Most of us are fairly introspective. We do a lot of mulling things over, and we take prayer seriously as well. But it has been only in middle age that I have gotten some inkling of God's role in my prayer. I suspect that the listening part of our conversations with God is a skill/gift/grace of middle age.

Similarly with the sharing that occurs so easily and naturally among women when we take time for one another. Earlier, comparing notes with our girlfriends was often colored with competitiveness. Sharing among middle-aged women is comforting and reassuring. We learn that we are not alone in our apprehension and hesitation about the changes and decisions that face us, and that in itself is empowering. We allow fewer barriers to our honesty and openness with one another than we did earlier in life.

Women in the Middle: Facing Midlife Challenges with Faith is intended to promote both prayerfulness about the issues of middle age and a sense of community among middle-aged

women. To be honest, sometimes my optimism in these pages is wishful thinking, as though claiming a particular value, learning, or victory would make it a reality. At other times, my humor about serious issues may seem like shallowness. In fact, finding the silly or incongruous element in life has been a helpful corrective to my own besetting sin of intensity. I seldom take matters too lightly. More often, I miss their meaning by not taking them lightly enough.

Speaking of women and community, this book flows from the community of women in my family, including Aunti Jean and Great Aunt Margaret Katharyn. I treasure my mother's sensitivity to language and my sisters' wisdom, especially my sister Paula's funny common sense and generous ear. I am grateful that my mother and I have both lived long enough to become women together. And as I write that, I realize that I can say the same of my daughter. Both relationships fill me with joy and gratitude.

So, blessings, reader, my sister, in this journey we share. May the chapters of *Women in the Middle* contribute to a sense of community with other middle-aged women, and an awareness of God's intimate involvement with us, every day of the way.

1

Taking Risks

When I was a child, I spoke like a child, I thought like a child, I reasoned like a child; when I became an adult, I put an end to childish ways. 1 Corinthians 13:11

Several years ago, a friend gave me an orchid plant. For twenty-five years I had nurtured yearly vegetable gardens and forests of African violets without success. Healthy plants looked at me, coasted for a while, and died. Seeds simply disappeared into furrows I copied straight from the pages of *Mother Earth News*, and were never heard from again.

But that orchid bloomed again and again. Encouraged, I decided to try another one. I listened carefully as the florist explained that an orchid can live for generations, that it should be included in one's will along with other family treasures of relative permanence. I followed her through the greenhouse to select one to take home, listening intently to her analysis of each plant's character. Finally, I narrowed the field to two. "This one is ready to bloom," she said of one. "The other one is more colorful when it blooms, but that may take five years." I surprised myself by unhesitatingly selecting the second.

I suspect that was my middle age speaking. "When I was a child," I chose the crop with the shortest time to the table. At the other end of life, my mother also goes for lettuce instead of asparagus, which could take several years to harvest. For example, she has to be cajoled into buying a larger television that

she could see more easily. At eighty-seven, she resists risking what she considers a long-term investment.

But at middle age, we're able to take risks more philosophically than earlier or later in life. It's true that many of the big decisions of life—marriage partner, children, initial career, for example—are made in young adulthood. But in middle age, we know the implications of the risks we take . . . and we still risk. During these years, for example, we support our children's launching out into their own lives despite our growing awareness of how nice it would be to have them close enough for easy visiting with them and with grandchildren, or, further down the line, when we ourselves might need assistance. We take professional risks flowing from questions like this: I have twelve to fifteen years before I retire. Do I want to spend them doing this kind of work? It's not uncommon for middle-agers to change professions, even when this might require going back to school or making extensive changes in lifestyle. Even remaining with choices of relationships, lifestyle, and profession made much earlier is a risk: Will I be able to change later if I want to? "I can put up with this job now," a friend confided, "but if things get worse in three or four years, I'll have a harder time finding a company to hire me."

She will make a decision, aware that both going and staying carry risks. Nevertheless, in middle age, she knows she has some skills and many years of experience in making big decisions. Similarly, she knows equally well that it won't be the end of the world if the results of her decision aren't what she planned or if she changes her mind later along the way. And so she risks making a conscious decision rather than coast—which, ironically, is itself a risk. Middle age may be precisely the place where hope and courage meet to undergird our decision making and risk taking.

Let us pray. Holy Spirit, thank you for the vision that enables us to see our lives and the world with the gradually increasing clarity of middle age. Flavor our willingness to take risks with wisdom, courage, and strength. Amen.

2

Overcoming
Painful Memories

See to it that no one takes you captive through phi-
losophy and empty deceit, according to human tradition,
according to the elemental spirits of the universe, and not
according to Christ. For in him the whole fullness of deity
dwells bodily, and you have come to fullness in him. . . .
Colossians 2:8–11

As I was finishing the ironing last night to the tune of the late
TV news, the weather forecast caught my attention. "It's going
to be a beautiful day tomorrow," said the forecaster as the col-
orful computerized maps unfolded across the screen. "Don't
worry about this," he added as he pointed to ominous-looking
clouds of orange and brown that dotted the map. "It's ground
clutter—distortions caused by radar, large buildings, or other
obstacles. It doesn't have any relationship to the weather."

I don't know much about meteorology, but that term caught
my fancy as I thought about the weather in my own life. For
several weeks, I had been investing my energy in a fledgling
friendship that already amazed me with the delight and trust
it engendered. But the other day, in mutual bantering with my
new friend, I said something silly, and was immediately over-
whelmed with a sense of shame that tarnished the silvery joy I
had experienced in the relationship. My shame was only par-
tially dispelled by my friend's reassurance; it clung to me like
splashed mud after a downpour.

Now, I have a word for that: ground clutter! I don't think I was born shameful, but I picked it up early. When shame seizes me, it's difficult for me to view myself accurately. My awareness is distorted by people-made static, just as the accuracy of the satellite image of the weather is diminished by power lines and radar and highway cloverleafs. But I've been in the habit of treating it as though it's real, as though I should be ashamed. Then I tuck my head down under the umbrella of my resolution not to be so free and spontaneous again.

We all have our own "ground clutter," such as snippets of painful memory that intrude into pleasant moments, or the habit of expecting doom in the midst of good fortune. But knowing that they are distortions of the real picture helps us to correct for the mistaken view, to acknowledge the presence of the orange and brown interference, and to move on out into the lovely day.

Let us pray. Lord, I know that nothing you create is bad, including me. I say that blithely enough. But I am so often held captive by old habits of dread, fear, and shame. Sometimes I weary of the work of dealing with them. At those times especially, remind me of your love for me. Help me to brush those familiar clouds away, living instead into the fullness of grace, freedom, and beauty that I have in you. Amen.

3

The Risk of Sharing

The angel went on to say to her . . . "You shall conceive
and bear a son and give him the name Jesus." . . .
Thereupon Mary set out, proceeding in haste into the hill
country . . . and greeted Elizabeth. Luke 1:30–40

Women's Diaries of the Westward Journey (collected by Lillian
Schlissel, New York: Schocken Books, 1982) is a collection of
snippets of journals written by some of the women who were
part of the covered wagon migrations from St. Louis to Seattle
and San Francisco beginning in the 1840s. By themselves, the
fragments are a terse but genteel record of struggle and heart-
break, where the role of the women was vital but generally un-
sung. But it is the modern historian commentator who brings
to our attention what must have added immeasurably to the
women's other sufferings: their isolation from one another.
The women

> . . . tried to maintain a circle of female care and compan-
> ionship. But for many, the overland journey seemed an
> assault on feminine propriety. . . .The need women felt to
> travel beside at least one other woman was hardly neuro-
> tic; it was a reflection of the very real and essential ser-
> vices, the daily services women performed for each other.
> (pp. 83,99)

We are little different from our foremothers, in that we still

need one another. The need for women friends persists, even when one's best friend is one's husband. We need kindred souls. We need to be heard, as individuals and as a group. Our society is gradually growing sensitive to women as a social group. The theoretical and administrative structures of religion and medicine, for instance, are inclined to take women more seriously now than in the past. A woman who confesses to her priest that she is abused by her husband may no longer be told that God wants her to try harder to please him, and a doctor will probably order a mammogram for a patient who complains of a lump in her breast, even if the doctor can't feel it yet.

But as individuals, we ourselves often fail to pay attention to one another. Despite the mythology of the kaffee klatsch, women often isolate themselves on the one hand, and fail to reach out to their sisters on the other. The proliferation of talk shows gives an impression of closeness that does little to bridge people's sense of isolation. "We live close together and we live far apart," says one of the neighbor women in Susan Glaspell's short story, "A Jury of Her Peers." Still, she muses, "We all go through the same things, it's all a different kind of the same thing!"

It's an amazing lesson for us, then, the story of the Visitation of Mary to her cousin Elizabeth. Luke's account is so economical of detail that we must assume that each word is there for a purpose. Traditional interpretations of the story focus on Mary's selfless kindness in going to help Elizabeth with the difficulties of her pregnancy at an advanced age. I wonder, however, if the story doesn't also affirm the need of women to share personal news and feelings with one another.

With the multiplication of sundry support groups, one would assume that such sharing happens easily and frequent-

ly. If television commercials were any indication, one might think that the color of one's urine or the state of one's sinuses is a matter of hourly conversations. It came as a surprise to all of us women who attended a recent "Lunch and Learn" employee health presentation on menopause that none of us had ever talked with anyone about our experiences with the various symptoms. "I asked my mother when she stopped having periods, and she said she didn't pay attention to things like that," said one woman. "I didn't know that it was normal to be more forgetful or to be less patient during menopause," said another. "I thought I was going crazy, but it sounds as though some of you have had the same experience." Our relief at finding through sharing with one another that we weren't crazy was nearly tangible.

Perhaps our reluctance to reach out to one another stems from time pressures. I suspect that it has more to do with our fear of entrusting our treasures and worries to others without knowing exactly how carefully they will be held. That's a big risk. All of us have experienced being let down by another's failure to respond to our pain or understand our fear or adequately join in our joy. I wonder what Mary's thoughts were as she traveled to see Elizabeth. Is it too far-fetched to imagine that she also may have been a bit apprehensive about the reception she would receive?

Let us pray. Mary, my sister, help me to reach out to others as you did, both to give and to ask for support. Strengthen me through the times when I am disappointed. Open my awareness to the understanding I do receive. Help me to be more sensitive to those who risk asking me for friendship and support. Through this, may we all become better listeners to the stirrings of God's life within us. Amen.

4

Living with the Either/Or in Life

Now as they went on their way, he entered a village; and a woman named Martha received him into her house. And she had a sister called Mary, who sat at the Lord's feet and listened to his teaching. But Martha was distracted with much serving; and she went to him and said, "Lord, do you not care that my sister has left me to serve alone? Tell her, then, to help me." Luke 10:38–42

In the tour book of my growing up years, Great Aunt Margaret Katharyn was the Statue of Liberty. I never met her, except through my mother's stories of her dedication as the wife of a Baptist missionary for fifty years in pre-Communist China. The early stories portrayed her as altruistic, genteel, organized, pioneering, and creative. As her namesake, I saw myself with the same idealism and dedication.

It was only fairly recently that my mother and her sister began to slip in vignettes about the other side of Great Aunt Margaret Katharyn's virtues. Childless, she could descend on her relatives' busy, crowded homes, and wreak her own orderly havoc: by alphabetizing the kitchen drawers, by spreading the farm dinner table with linen tablecloths she had brought from China—that someone else then had to launder and iron, by silently reproaching the homefolks with their lack of the amenities of a missionary's household, complete with native servants.

In my lifetime, I realize I've managed to live out both sides of Great Aunt Margaret Katharyn's contribution to the family. I get things done, but sometimes not the way those most affected would wish. On one side, I'm a woman of action and efficiency. On the other side, I can be self-righteous, especially if my house is clean and my calendar is under control at the moment.

It is out of this kind of reflecting on my own middle age and that of my friends that I've arrived at the semi-facetious idea that the Martha-Mary story was edited by a very young person. Dichotomies are easy when one is young. Religious educators and developmental psychologists describe the stages through which children move in their rationale for moral decisions from blanket good-versus-evil to a richer but more complex view of life and morality that includes shades of both, sometimes simultaneously. That pattern of growth probably characterizes many areas of human existence, from personality traits to career and lifestyle choices. There are few either/ors in life, and many boths and back-and-forths. By middle age, we're beginning to understand that. A student my age grieves that "You can't have it all," and in the next breath, we both reflect on how much we do have. My sister describes with equal intensity both the pain and the joy in her thirty-year marriage. In retrospect, those moments have sounded both frustratingly entangled and beautifully blended.

Is middle age at least partly named for our realization that life is such a blend, rather than an either/or? And how have we reached that integration? One explanation is that life itself forces us, by presenting unavoidable opposites to be brought together. Robert Frost may have thought that he could not follow both of the roads he found in the yellow wood "and yet remain one traveller." But the truth is that the grocery store

lies in one direction and the babysitter in the other; disapproval of an errant child on one path, and enduring parental love on the other; need for closeness to one's husband on one hand, but need also for independence. By middle age, we've figured out how, in each example, to do both in one trip.

Let us pray. Jesus, we do notice that you didn't work one of your meal miracles to help Mary and Martha out with their conflicting job descriptions. Was it your grace, then, that helped them to learn to feed both body and soul at the table you and they spread for one another? Send us your grace and wisdom as we continue to find that nourishing, integrating balance in our own lives. Amen.

5

Learning Our Limitations

The centurion answered, "For I also am a man under authority, with soldiers under me; and I say to one, 'Go,' and he goes, and to another, 'Come' and he comes, and to my slave, 'Do this,' and the slave does it."

Matthew 8:5–13

The arrival of my adopted son coincided with the beginning of the Wiffleball season, and I signed him up with the local children's league. Fresh from Cambodia, he had the body of a baby bird, the voice of Pavarotti, and the ego of Arnold Schwarzenegger. It soon became apparent that he wouldn't get much playing time because of his meager size. While I weighed the pros and cons of intervening with his coach, I also used the opportunity to Instruct My Son About Life. "Honey, the team needs good encouragement from the players on the bench just as much as it needs good players on the field," I told him, and I gave him some acceptable yells like, "You can hit it, buddy" and "You'll catch it next time." Shortly, however, I realized that it was time to teach him about the deceptively fine line between cheering and coaching. I'm fairly certain that this philosophical distinction was lost on my son. The adjustment in his behavior was probably attributable to his slowly growing awareness that he would be spending the rest of the season warming the bench if he attempted to take over too much of the coach's job.

Not a bad lesson to learn, even that young. Limitations are a

fact of life for all of us, regardless of age. I watch young adults move from "We can do it all," to "We can probably do a lot, gradually." Our nation seems to go through alternating cycles of unlimited optimism and cynical isolationism about poverty, violence, and international armed conflict. Personally, locally, and nationally, we struggle to identify and deal with our limitations.

In my fantasy version of the centurion's encounter with Jesus, what took place (besides the centurion's demonstration of piety and faith and Jesus rewarding him, of course) was the meeting of two executives for a frank sharing about the jobs of each. "I command armies and household servants," says the centurion. "But I can't command the forces of nature, life and death. I've heard that you do that." "I do," says Jesus. And he does. He promptly cures the centurion's servant.

It occurs to me that by middle age, we've made our peace with many of the "rules" of the life we've chosen, just as Jesus and the centurion were clear about their realms of influence. The shifting economy and ageist personnel policies in some companies have artificially disturbed the former relative security of this stage, admittedly. Shifting family structures and social values challenge us on the home front. Still, by middle age, we've learned how things work, and we've learned how to do what we want to do—and let go of what we can't do—within those parameters. This is quite different from the "selling out" that younger voices sometimes accuse us of, at one pole. And at the other pole, middle age is a bit young for testing our prophetic voice. Rather, this is a time of coming to terms with what *is*. For example, I know now that while I have a few suggestions for my boss, I no longer want his job. I've learned to live on my salary instead of his, for one thing. For another, he has the job at present; it doesn't seem likely that he will ab-

dicate in my favor in the foreseeable future. But more than anything, I like most of what I'm doing. And I've learned to negotiate, ignore, or compensate for the parts I don't like. I couldn't say that before middle age.

Let us pray. Jesus, thank you for the relative peace I've found at this stage in my life. It opens me to the contentment that earlier seemed to lie just over the professional horizon or around the next personal corner. Please extend that peace to the places where I still struggle and flail away to claim a place or to prove my worth. Remind me that I already have a place and worth in your eyes. Amen.

Resting on Our Laurels— Comfortably

Now his elder son . . . answered his father, "Listen! For all
these years I have been working like a slave for you, and I
have never disobeyed your command. . . ." Then the fa-
ther said to him, "Son, you are always with me, and all
that is mine is yours."' Luke 15:25–31

One of the silliest clichés in the English language, it seems to
me, is the one about not resting on one's laurels. I recall an ex-
tended interchange with a friend about that several years ago.
Semi-playfully I advocated devoting a fair amount of one's at-
tention to doing precisely that. After all, I reasoned, if one has
accumulated any laurels at all in terms of personal growth or
professional accomplishments in life, the most appropriate re-
sponse imaginable is to rest on them, at least for a while.
Subsequently, we carried our discussion into literal action
when she brought me a bunch of laurel branches used by flor-
ists for packing and filler. I doggedly watered them, and sever-
al months later they burst into exquisite blooms.

What perverse streak in human nature is it that makes it
seem either morally, psychologically, or logistically dangerous
to celebrate our victories and successes? We seem much more
comfortable with our problems and failures. Perhaps there is a
message in scripture for the honestly virtuous as well as for
the contrite. An important subplot in the story of the Prodigal

Son revolves around the elder son. Note that both he and his father affirm his claim of hard work and faithfulness. Certainly, laboring in the family business isn't easy in any culture or period of history. Adherence to the laurel rule would have required the father to admonish the elder son with some version of "Pride goeth before a fall," or "Praise to the face is open disgrace," instead of the affirmation he does give.

I suggest that by middle age, we have accumulated all of the elements necessary for good resting on one's laurels. First, we've lived long enough to be able to claim a few significant accomplishments. At the very least, we've reached middle age. Barring calamity, those with children have seen them grow. Those with husbands have seen both of you grow. We've lived through tragedies, gone to school, learned skills and hobbies, cared for our parents, painted our houses, furnished our apartments, and made car payments. We've lost jobs and survived. We've made mistakes and learned from them—and can admit it. We've engaged in family fracases and reconciliations. We've been around the block, as the saying goes.

Second, we've built at least a small community of friends whose history with us enables them to understand and appreciate our particular laurels. When I recently told a friend that I had just completed a year of bagpipe lessons, she obliged me with a reverential, "Wow! a whole year!" instead of "Whatever for?" Lonely as it sometimes seems for all of us, the chances are that we have made at least one friend who understands the victory of marking an anniversary, completing a course, changing the oil in the car, going to a counselor or support group for the first time, accomplishing a move or other transition. The list of laurels is as varied as we are.

Finally, by middle age, we have the panache to rest on our laurels with the style they deserve. A friend of mine once con-

fided that she loved Baked Alaska, and so I served that instead of a traditional birthday cake when I hosted a family party for her. The children present were horrified at the breach of tradition, and the elders tsked! tsked! at the mess. But we middle-agers knew that Baked Alaska was the only fitting monument to another year of her life. What a life! What a laurel!

Let us pray. Dear Friend, you know how often I've come to you with shame, regret, and contrition for my failures, lapses, and limitations. Teach me the truthfulness that allows me to sing with joy at my gifts, skills, successes, and victories. Thank you for those around me who can share my celebration of them. Amen.

Dealing with Unruly Feelings

> In the beginning . . . Earth was a formless void and darkness covered the face of the deep . . . and God separated the light from the darkness. God called the light Day, and the darkness he called Night. Genesis 1:1–5

Some years ago, I went to a counselor for help in dealing with some patterns of behavior that were causing me a good bit of pain and frustration. Over the weeks of sharing a number of difficult feelings, I noticed my propensity for putting them into categories. "Oh, yes, I recognize that feeling now," I would say. "It's the same feeling I used to have when . . ." Or, "I can't think of a word for that feeling . . . except fear. That's it!"

My sense of relief at finding a category—a memory, term, or theory that would capture (literally) each difficult feeling—was tangible. As time went on, I came to imagine the categories as a set of containers, like cake boxes, lined up on the other side of the office. Sometimes the categories were helpful, as when I gained new understanding about one relationship or transaction by comparing it with a similar one. For example, my struggles with a colleague made more sense to me when I noticed the similarities between our roles at work and my role in my family of origin. That awareness gave me a measure of freedom from re-enacting an old script that didn't fit the new environment.

Sometimes, such categorizing was not helpful. Periodically, I too quickly stored painful or intimidating feelings in the boxes instead of dealing with them in more integrating ways. Sort of, "Thank goodness I don't have to have that sorrow; I have a name for it instead." Jesus warned about the demon who returns with "seven other spirits more evil than itself" (Luke 24:26), and the same might be said of unruly feelings that are banished, rather than confronted.

Reflecting on that experience helped me to realize anew both the danger and the comfort in categories, in structuring our feelings and experiences. God must understand. Else, why would the first Scripture story about God focus on imposing order and structure on the chaos of the universe? Chaos holds the potential for both danger and creativity, but we are seldom equally in touch with both potentials at the same time.

I suspect that it's our creative, trusting side that entices us to tolerate the chaos outside the boxes for a little while before we rush into the struggle to tuck it away. "Something there is that doesn't love a wall," wrote Robert Frost in "Mending Wall." His neighbor smugly and unquestioningly defends the wall dividing their property with "Good fences make good neighbors." But Frost presses the question:

Spring is the mischief in me, and I wonder
If I could put a notion in his head:
"Why do they make good neighbors?"

The fence is probably an inevitable way of structuring the land and the owners' relationship. Nevertheless, the poet persists,

Before I built a wall, I'd ask to know
What I was walling in or walling out.*

I face the same question myself, as I press myself to look at the feelings, questions, and decisions I thought I had boxed up and fenced in long ago.

Let us pray. Dear Guide, you know how I long for the comfort of routine, structure, predictable control. Support me now, in middle age, as I reflect on the experiences and feelings that I find disquieting and unsettling. Strengthen and encourage me as I approach them rather than avoid them and tuck them out of sight. Amen.

The Poetry of Robert Frost, ed. by Edward Connery Lathem (New York: Holt, Rinehart and Winston, 1979), pp. 33-34.

8

Productive, Satisfying Complaining

The bread I eat has become like ashes;
what I drink is mixed with my tears—
all because of your anger.
Psalm 102:10–11

A few years ago, in my very early middle age, I lost a romp
with my dog and spent the next six weeks in an ankle-to-hip
plaster cast. It was heavy and awkward to lug around, and my
leg itched unmercifully underneath it. I must have worn the
ears off my friends with my complaints about how much it
hurt and how I longed to scratch my knee, located two inches
lower than I could reach with a coathanger.

Have I ever regretted wearing their ears off? Heck, no! No
one can complain like a middle-ager. I've begun to wonder if
good complaining, like fine wine, reaches its prime only with
some aging. Of course, there are a few limits, beyond which
both good complaining and fine wine turn to vinegar. But mid-
dle-agers know that limit, and operate within it with panache.

Listen to the complaints of the Psalmist (102:7,5): "I am like
a pelican living in the wilderness, or a screech owl haunting
the ruins . . . my heart withers like scorched grass; even my ap-
petite is gone." Only someone who has been around the block
could complain like that. "I lie down among the lions hungry
for human prey; their teeth are spears and arrows, their tongue
like a sharp sword" (Psalm 57:5). We've all attended enough

25

contentious committee meetings to empathize with the psalmist's description of his situation.

And yet, in each psalm, there is a resolution to the problem, a response of some kind to the complaint. The depressed writer of Psalm 102 (v. 18) arrives at the trust that Yahweh "will answer the prayer of the helpless and will not laugh at their plea." The beleaguered suppliant concludes that Yahweh's "love reaches to the heavens, [God's] faithfulness to the clouds" (Psalm 57:11).

My theory is that middle age is a prerequisite for productive, satisfying complaining. In the first place, by middle age, we've had enough life experience to develop a sense of proportion that gives our complaining both substance and credence. We know that some things are worth complaining about and others aren't. That doesn't mean that we forego expressing our feelings about minor issues; it means that we can make some choices about what we bewail and protest. I felt better when I expressed my discomfort with my cast, but I knew the point at which my carping would alienate my friends. In a different arena, I know when my criticism at staff meetings can help us focus on defining and solving a problem, and when it merely frustrates my colleagues to the point where they dismiss my opinions. We've all heard our share of PMS "jokes" that help others—and perhaps us, as well—to deal with our discontent at the same time that they discount our contributions. Sometimes I decide not to "sweat the small stuff." At other times, I opt for the relief I find in a satisfying, well-phrased complaint.

By middle age, our life experience has provided us with a realistic awareness of the situations and conditions we complain about that lends authenticity to our laments. And by that time, we know that life goes on, past disappointments, hurts,

severed relationships, broken promises, and heart-breaking tragedies. That gives us both the energy to complain lustily and the hope to carry on.

Let us pray. Thank you, dear Friend, for staying close, for listening to me both when my complaints are reasonable and when I am only cranky and out of sorts. Bless me with patient and supportive colleagues and companions. Then, help me to temper my laments with a saving sense of proportion and humor. Amen.

9

Dispelling Worries and Regrets

Just then there was in their synagogue a man with an un-
clean spirit. . . .But Jesus rebuked him, saying, "Be silent,
and come out of him!" Mark 1:23–25

After years of trying, I am finally able to draw some boun-
daries around various segments of my life, so that I leave my
work worries at work and home problems at home. At best, I
can do that with some regularity. But one afternoon, it proved
impossible. I picked up my son from school and asked the usu-
al questions about his day, but was evidently more pre-
occupied than I realized. Finally, after several blocks, he
turned to me and asked, "Mom, is your brain talking to you in-
side your head?" Embarrassed, I tried to explain myself: "Well,
yes, but don't *you* ever get caught up in your own thoughts?" I
asked. "Yeah," he agreed, "but I don't move my mouth and
wave my hands."

Actually, we all talk to ourselves "inside our head," I sus-
pect. Adolescents typically carry on a lot of awkward self-talk,
reflecting their anxiety at fitting in when both they and the
world are changing too rapidly for comfort. "She thinks you're
gross," mutters the fourteen-year-old's brain to himself. "Your
face is pimply, your clothes are wrong, and your haircut is
ugly. And Mom won't let you get your ear pierced!"

Middle-agers also carry on two-part monologues. "I should

have said . . . " and "Next time . . . " clutter our internal airwaves, too. John Bradshaw, in *Healing the Shame That Binds You*, refers to "toxic" shame, a demon that flows from a pervasive sense of never being good enough, worthy of regard, or acceptable. He distinguishes this from healthy shame, which reminds us of our natural limitations and so insures our safety. By middle age, we've figured out where some of those messages originated, and we're more comfortable with our blemishes and limitations. Experience tempers any inclination to grandiosity we may have. We've learned to differentiate our own voice from other voices from our past. That gives us some mastery over them, at last.

For example, in some social situations, my witty, competent, energetic self seems to disappear behind a pudgy, shy, awkward teenager. Forty years ago, I *was* pudgy, shy, and awkward, though probably not nearly as much as I felt. These days, however, when I hear that old voice begin to speak, I remind her that she has no reason now to feel so awkward and ugly. My adult self is the one in charge, and I can care for myself and for her, too, I tell her. Then she leaves, finally as comforted as she longed to be so many years ago.

Obviously, I haven't vanquished all my demons, only most of those I've dragged along with me through the years. That happens by middle age, I think. Now we know with clarity which are the demons from our past who no longer belong and so can properly be exorcised, and which are the worries and regrets which appropriately demand our attention and for which we now have ample resources of creativity, strength, and experience.

Let us pray. Jesus, with good reason are the demon stories in the gospels filled with such violence and drama.

Demons are powerful. Help me to be aware of the old demonic voices within myself that trap my attention and energy. Give me the initiative and strength to subdue them when they limit my joy, creativity, and effectiveness in your service. Amen.

10

Slowing Down,
Stepping Aside, Resting

Our hearts are meant for thee, O Lord, and will not rest
until they rest in thee. St. Augustine

I made an interesting discovery today, as I tried to track down
the source for this quotation. Wading through pages of as-
sorted references, I learned that writers uniformly confuse rest
with either sloth or death. "If I rest I rust," declares Martin
Luther (*Maxims*). "Teach us, good Lord . . . to toil and not to
seek for rest," echoes St. Ignatius in his Prayer for Generosity.
"Rest in peace," we pray in the funeral liturgy. "Rest, per-
turbed spirit," Hamlet wishes for the ghost of his murdered fa-
ther (I, sc.5, v.182). And of course, we have all heard that "Idle
(resting?) hands are the devil's workshop."

Frankly, I can't help but wonder how Augustine's mother
viewed the notion of rest. Standard biographies portray
Monica as a woman who devoted her life to the formidable ef-
fort of guiding her young son along the straight and narrow
path of righteousness. Augustine himself attests to his dedicat-
ed resistance to that. His *Confessions* describes the various
kinds of adolescent cussedness in which he energetically and
enthusiastically engaged.

Any parent who has lived long enough to hear her offspring
ask advice or clean house can understand that Monica prob-
ably felt the need of rest once her son's life turned around. I

wryly note that Augustine was in his thirties before he settled down. There is probably some truth to the aphorism that a mother's work is never done. At least the worrying part may not be finished for a long time. Jesus himself periodically took time out to rest, long before he rusted or died. Unfortunately, however, by the time we reach middle age, we may have forgotten how to rest.

This is a good time, then, to reflect on Jesus' custom of occasionally taking his apostles away from the daily crowds and routine, and on what happens for us when we follow that practice in our own lives.

We pray. Our lives are so filled with conversation and activity. Of course, that doesn't stop automatically when we take time to slow down, to step aside, to rest. But I find that in those times, the other side of the conversation is more apt to be held up by God than by replays of the day's confusion. Certainly God also speaks to me through the people and circumstances of my daily life. But somehow, the Voice that speaks to me in the quiet, restorative times seems just for me.

We listen. It's no coincidence, I'm sure, that my "Aha" moments come when I'm quiet, if for only a few minutes. As I've earlier said, I so often engage in a lot of self-talk and imaginary second-guessed dialogue with others. But when I'm resting, quietly letting my mind lie fallow, I find that God's voice is often the one that speaks to me, and I am finally able to listen.

We regain a healthy sense of distance and proportion. Injuries that seemed disabling, slights that could damage or destroy a friendship, problems that appear insoluble generally become more manageable when we're rested—genuinely rested, rather than distracted. Substituting one busy activity for another doesn't provide the same kind of helpful distance that good rest and quiet does. Rest enables us to rediscover old tal-

ents, skills and resources, and to see where those match current situations.

Let us pray. Lord Jesus, we pay a lot of attention to your example and teaching about so many other facets of our lives. Help us to hear you on the subject of rest, as well. Remind us frequently about the importance of rest, especially when our lives are overcrowded with pressure and activity. Help us to create a place in our lives, our schedules, our hearts, where you can come to us, and where we can hear your loving, healing words to us. Amen.

Virtues Birthed in Middle Age

God said to Abraham, "My covenant I will establish with Isaac, whom Sarah shall bear to you at this season next year." Genesis 17:21

Of all the wonderful characters that file through the pages of Scripture, my hands-down favorite is Sarah. Admittedly, Sarah was not always a sympathetic character. Abducted by Pharaoh, she brought such a collection of plagues with her that Pharaoh thought it good riddance to release her and so sent her entire household on their way to the land the Lord promised them. When it appeared that she was barren, she arranged a liaison between Abraham, her husband, and Hagar, her servant. But when a child was born of that union, Sarah dealt so harshly and vindictively with Hagar that she ran away, seeking refuge for herself and her son in the wilderness. Finally, when Sarah, standing inside the family tent, heard the angels tell Abraham that she would give birth, she laughed out loud. But when the angels confronted her, she denied her guffaw, "for she was afraid" (Genesis 18:15).

Many aspects of the Genesis account are allegorical, positioned to reinforce a point about God or a judgment about the practices of the time. Nevertheless, the characters that emerge are so lifelike and the ordinary details of their lives so finely drawn that we cannot help but be attracted to them. Part of my

affinity for Sarah is age; I was no "spring chicken" myself when I began adopting children. However, my fascination with her includes an interest in what else she gave birth to before she reached old age and the arrival of Isaac.

Of course, anyone who has reached middle age knows the value of a sense of humor. Do you remember times when you laughed with relief, as a way of breaking the tension? Or because matters reached the height of the ridiculous? Or because laughing seemed a better choice than crying? Given her history, Sarah knew a bit about both the pleasure and the pain of family life. I think her laugh was more than incredulity that she would give birth at her age. I propose that it was a philosophical acceptance of whatever happened, sort of a wry "What on Earth is God planning now!" After all, Sarah—and we—knew that God had already planned quite a few surprises . . . and life goes on.

Of course, an element in Sarah's philosophical approach was her healthy respect for her limitations. It was one thing to giggle at angels, quite another if they took offense. Undoubtedly, it was wisdom born of experience that convinced her not to take them on directly, at least not then and there. Midway between the brash energy of youth and the patient resignation of old age, middle-agers have learned to pick their battles, and to back down gracefully from those they can't win.

What I love most about Sarah, however, is her fidelity. The twists and turns of her life with Abraham as God's Chosen are unparalleled in the Old Testament, and she might have been forgiven a loud complaint or querulous demand for better timing or more thoughtful planning by the One in Charge. On the other hand, Sarah's faithfulness to God and to her family was no mealy-mouthed subservience or passive acquiescence.

Sarah's obedience to God's plan was the kind we ourselves know: the roll-up-our-sleeves variety that has gotten us to middle age in one piece. Knowing this Sarah, I imagine that both she and God at some point must have enjoyed a hearty laugh together in sheer celebration of the comfortable familiarity and practical, enduring strength of their covenant with each other.

Let us pray. God, each day brings us new births. Each day we discover some talent we didn't know we had, some opportunity to help another, some delight that appears unexpectedly. Each year brings new learning, fresh awareness, deeper understanding about the meaning of our lives and your presence there. Help us to be receptive, regardless of the adjustments and adaptations they may require. Amen.

12

Seeing Miracles
in Little Things

Consider the lilies of the field, how they grow; they nei-
ther toil nor spin, yet I tell you, even Solomon in all his
glory was not clothed like one of these. Matthew 6:28,29

Did you ever notice that when Jesus really wanted to make a
point, he focused on little things? The kingdom of heaven is
described in terms of a mustard seed or weeds among wheat
or yeast mixed into flour. "Big" miracles like the feeding of the
five thousand and the unexpected catch of fish began with
simple things like a few loaves of bread and a night's fruitless
labor. Jesus seemed to downplay the relative importance of
events like the Transfiguration and the various cures he ef-
fected. When Peter wanted to build a shrine on the place
where he saw his friend's glory revealed, Jesus told him not to
make a fuss about it, and they returned promptly to their daily
routine. Restoring movement to a paralytic was minor, Jesus
said, in comparison to the less dramatic but more important
miracle of the forgiveness of sins.

I doubt that we can appreciate that fully before middle age.
My theory is that middle age must bring us to that place where
we first see and truly appreciate the miracles in the "little
things." I think of how much I look forward to an hour with
the newspaper and a cup of coffee with vanilla and cinnamon
early on Saturday mornings. That alone could "cure" me of a

week's worth of stress. The warm greeting of the bus driver transforms a drowsy "Here-we-go-again" Monday morning into an energizing reconnecting with work-week friends. The harvesting of the season's first homegrown tomato, your husband's arm around your shoulder, my son's discovery of a book that I enjoyed when I was his age, a letter from my daughter, a moment to reminisce over the refrigerator door family archives—no one can celebrate those moments quite like those of us in middle age.

There's something about middle age that sensitizes our sight to the tiny threads in life's fabric. I can sail over all sorts of stormy seas on the affirmation in a letter from a reader of something I've written. My daughter alludes to her fond memory of the ways we celebrated the Fourth of July when she still lived at home; at the mention, I forget how tired I used to get and how infuriatingly nonchalant she seemed at the time.

Our souls are more easily filled in middle age than when we were younger. As much as I relish my daily walk, I used to pass it up if I couldn't take my Walkman tuned to the local classical station. Now all that overloads my senses, and I find myself listening intently to the sound of the locusts or the breeze in the trees as I march along. A local video store offers a "threefer," but as much as I love a bargain, I am never able to enjoy more than one movie before they have to be returned. Some days I'm content simply to sit in the quiet house. I find that even my prayer takes less planning and structuring; I am more trustful of the process of waiting and listening.

Of course, all this may be because, by middle age, we're simply tired. But I doubt it. Flannery O'Connor maintained a flock of peacocks on her plantation in Milledgeville, Georgia. She said that their splendor would "knock the eyes out" of those who were unimpressed by the simple beauty of her

barnyard geese. Perhaps one of the "big" miracles of middle age is that we finally see the simple beauty of the world that has been there for us all along.

Let us pray. Loving Creator, I've praised you many times for the beauty of nature and of the people you've placed in my life. Today I am grateful for the maturing and quieting of soul that now opens my awareness to all the nourishment and beauty in the simple, quiet, seemingly unremarkable facets of the world within and around me. Thank you. Amen.

13

Sharing Our Shadow Side

Then the eyes of both were opened, and they knew that they were naked; and they sewed fig leaves together and made loincloths for themselves. Genesis 3:7

Poor Adam and Eve have taken a beating. Because of their disobedience, in the words of the folk song:

They took a hoe and they took a plow,
And that's why we're all workin' now.

That said, there's some saving grace in that doleful tale that middle-agers know more about than anyone else. The truth is that Adam and Eve still had each other, after the Fall. This is far more than the old saw that "misery loves company." When we're young, we invest a lot of energy in keeping secrets, in hiding our orneriness—our nakedness—even from those we are closest to.

But by middle age, we are often better able to share the dark corners of our souls with others. For instance, aware of the history of abuse suffered by most of my adopted and foster children, I know how important it is not to punish them with physical force. But one evening, I really wanted to strike one of the older children. I was ashamed of my own violent impulse.

That evening, I confessed my sin to a good friend. To my surprise, she shared a similar story about nearly coming to blows with her son the day before. We were both shocked by

our impulses, but somehow our "nakedness" seemed more manageable together. The companionship enabled us to see our strength in the situations we were dealing with. We laughed together when I described the startled look on my child's face as I drew back from the verbal altercation and announced that I needed to take "time out." My friend felt confirmed in her sense that it was time to look for additional services to deal with her son's disabilities. And we both felt normal, not evil.

By middle age, we are willing to be a bit more vulnerable with one another. Perhaps we are less judgmental about others because, by this time, we've seen ourselves do things we never thought we would. I never thought I would give up on a child, but I learned both as a teacher and as a foster parent that there were some children I couldn't handle, for instance. "I never dreamed that I would ever send one of my children away," shared a friend. "But it was either that or the rest of the family, and so we finally moved him into an apartment for a time." My own experiences seem more manageable and the divisions less final as I listen to hers.

It occurs to me as I reflect on the Garden story that, while Adam and Eve were driven from the Garden as a consequence of their violation of God's injunction, they didn't go alone. The entire Bible is a record of God's continuing presence with them and their descendants as a People. The gospels are filled with story after story illustrating the redemptive power of sharing our weakness, need, and regret with one another. "Father, I have sinned against heaven and before you," confesses the Prodigal Son, and he is welcomed back into the family (Luke 15:18). "We indeed have been condemned justly," acknowledges the Good Thief, and Jesus reaches out to him without reservation: "Truly I tell you, today you will be with

me in Paradise" (Luke 23:43). Ordinarily, "Jews do not share things in common with Samaritans," John writes to explain the surprised reaction of the woman at the well when Jesus asks her for a drink (John 4:9). But Jesus persists, and she allows herself to be coaxed into sharing first a cup of water and then the story of her shame. Is it possible that she thus received a foretaste of the eternal life he promised, even then, in his company at the well?

Let us pray. Dear God, we have invested so much in building our reputations and maintaining a facade both for ourselves and for others. Be with us as we risk admitting and sharing our vulnerable places with friends who can support, comfort, and encourage us. In that way, strengthen us in our daily struggles. Amen.

14

Valuing Silence

Meanwhile, standing near the cross of Jesus were his
mother, and his mother's sister, Mary the wife of Clopas,
and Mary Magdalene. John 19:25

Several months ago, I had the last of a series of surgeries. I was
beginning to understand the routine, and knew that I would
probably have to wait for a long time in the pre-op holding
area. I had generally gone by myself, but this time I was weary
of being frightened alone, so I accepted a friend's offer to go
with me. My anxiety pushed me to tell her straightforwardly
that I couldn't handle small talk at that moment, but that I des-
perately needed someone to be quiet with me. "I understand,"
she said. "I'll bring my prayer book so you won't feel like you
have to entertain me, and we can talk if you feel like it." It was
then that I knew that I had a very good friend indeed.

Social commentators are fond of pointing out that the tele-
vision generation has lost the art of conversation. I would say
that a more serious loss is the ability to be quiet with one an-
other. Of course, there are plenty of times of silent non-
communication, as when children sit glued to the TV, unable
to participate in anything going on around them. In contrast,
silence can be a very powerful medium of communication.
Mary's companions at Calvary knew that some pain is beyond
words to express or alleviate.

I am always struck by the relative quiet in hospital rooms.
Sometimes the atmosphere is anxious, sometimes sad, some-

times peaceful or thankful. In one room, nothing can be said. In another, nothing should be said. In others, nothing need be said. I've noticed how easy it is in our pastoral care classes to focus on words; the topics explored and the expressions chosen by patient and chaplain become the center of our examination. It is easy to overlook the pauses and their meaning in the caring relationship.

I suspect that developing our tolerance and appreciation for silence is a gradual matter that doesn't begin to flower until middle age. One of my sweetest childhood memories is of summer evenings when the neighborhood adults would gather on one front porch and watch the twilight descend. Conversation was sporadic and comfortable. We children were allowed to listen to the quiet as long as we behaved. I suspect that this was where I began to learn from the grown-ups about the value of silence. It was a lesson that needed to age, however. It is often much easier to fill time and space with words and other noise than it is to risk the quiet.

Clearly, Mary's silence was not a lack of the ability to communicate, any more than Joseph's silence was. For instance, I can't imagine that she let twelve-year-old Jesus off the hook so easily in the Temple where she and Joseph found him after three days of searching. And as a parent myself, I'd be reassured to know that her "pondering all these things in her heart" was plenty more than the holy thoughts generally attributed to her on that occasion (Luke 2:41 ff).

It also strikes me as worthy of reflection that we hear nothing about her presence in the early church, despite the assumption of Christian tradition that she was honored and influential. Her silence must have been very powerful indeed. And legend tells us that John, pressed again and again as he grew older to verbalize some legacy for the early church,

would say only, "Children, love one another." No further words were needed.

Let us pray. Jesus, it takes a long time to learn about silence, its meaning and value. Protect me from the temptation to take what sometimes seems like a safer choice, and to fill my life and relationships with words and activities so that there isn't any room for silence. Amen.

Rhythms of Life

Thus the Lord blessed the latter days of Job more than his
earlier ones. Job 42:12

This book began in my head at a time when I was more aware
of feeling restless, at loose ends, than ever before. Suddenly
the nest of my home was empty. I was approaching a longev-
ity record in my work, having stayed in one place longer than
usual. On the one hand, it felt as though I should be content; I
had time for the hobbies—reading, needlework, music—that I
had never indulged before. But on the other hand, I missed the
loss of the Big Projects that had occupied my professional and
personal life in the past: rearing children, completing a long
professional certification process, creating and settling into a
new job. . . .

I've become aware of the negative connotation of so many
of the labels and experiences of this time in life, *"empty* nest,"
for instance. I look at my new freedom to go window shop-
ping or people watching or library browsing on a whim, with-
out carefully balancing the schedules of others who have
needed me in the past—and it feels as though there is some-
thing not quite right about "wasting time." I keep looking over
my shoulder with equal amounts of wishful thinking and ap-
prehension to see if there isn't somewhere else I should be or
someone else's need I should be responding to.

And the physiological changes that are occurring? I view
them with mixed reactions. I'm a bit proud of the gray streaks

in my hair, feeling that they're an acceptable sign of my hard-earned maturity. A young colleague observed guilelessly, "You've got a lot of wrinkles . . . but they're laugh wrinkles." I readily claim those. Not so my wrinkled pouchy stomach.

It seems to me that one of the tasks of this life stage is to reframe some of these developments, experiences, and realizations so that we can get to their truest meaning for us and those who share our life. For instance, I wonder if the hidden gift in my propensity for saving steps and economizing motion these days doesn't lead me to dwell on the meaning of the small things around me. The pot of African violets in my front window touches me with its delicate beauty in a way that my sprawling yard and garden never did. Now at the end of menopause, I feel myself moving from the rhythm of a monthly cycle to larger rhythms outside myself: the seasons, anniversaries, family rituals. There once was a time when my year was measured in segments divided by report cards, changing shapes of after-school and summer programs, and children's sports. Now I am freer to set a more flexible schedule. I've noticed that I'm content to finish a project by the time it's finished, not by 3:00 or by Monday or by November. I find that I mark rhythms differently, too. This season, for the first time in twenty-five years, my annual Christmas letter will go to a small group of close friends rather than to the long list of old acquaintances I've struggled to hold on to through the years.

It's no surprise that people our age begin to look differently at service to others, and to turn from Girl Scout cookie sales and field-trip chaperoning to projects outside our immediate world, such as Habitat for Humanity, Literacy Council, soup kitchens, and hospital auxiliaries. And we aren't looking so much for a way to fill our empty time. Few of us are retired, and our time is still a scarce commodity. Our choices of service

activities have more to do with our growing freedom to look at the larger world outside our home and to invest ourselves in it.

Let us pray. God, you know that I've welcomed and even prayed for some of the changes in my life. This one's a little harder. Free me from the stereotypes and habits that dim my view of the blessings of middle age. Open my eyes to the gift of these years, and to your presence in the experiences of this time. Amen.

16

What Our Possessions Say About Us

The beginning of wisdom is this: Get wisdom, and what-
ever else you get, get insight. Proverbs 4:7

Several years ago, my son embarked on that childhood ritual
known as music lessons. Accordingly, I purchased a half-sized
violin for him at the local music store, paying for it with one of
my personalized checks. "Do you need identification?" I asked
the earringed, T-shirt clad young clerk. "Nope. Listen, lady,"
he drawled. "Anybody who pays for a kid's violin with a
check with little bears on it has gotta be honest."

The fellow's method of assessing the trustworthiness of his
customers led me to reflect on what my possessions say about
me as well as on how I've selected them. It's a truism that ad-
olescents act out their identity struggles in terms of their cloth-
ing; they strive to look unique, but not too unique. My
thirteen-year-old son is acutely aware that his world is pop-
ulated by three groups: "brains," "punks," and adults. There's
no question about his shunning adult neckties and belts. But it
is clear from his wardrobe that he struggles with the choice
about which of the other two groups he will join on any par-
ticular occasion. To a great extent, at his age, he really is what
he wears.

Young adults also seem focused on what others have as the
norm for their own acquisitions. The "Dress for Success"

movement attracted those who were fairly new to a professional world where workers were identified by the quality of their clothing and jewelry: their work "uniform." Within the budgetary limitations of those just starting out on their own, young couples are keenly aware of how their peers celebrate their weddings and what neighborhood they choose for putting down roots.

By the time we reach middle age, however, things look different to us. I used to think I hadn't really "arrived" until I owned a house, for example. Now, in middle age, I've decided that there are other ways I want to spend my time than mowing the lawn and painting the trim. When many of my contemporaries are looking at country property, I moved into an older apartment complex that houses a mix of ages, family types, and ethnic groups that I enjoy. I luxuriate in the contentment of seeing neighbors close by, even in hearing an occasional thump on the wall as the children next door romp together before going to bed. It doesn't matter that such closeness isn't everybody's cup of tea; it is mine. But I don't think this was as clear to me or that I made my choices so freely and independently earlier in my life.

As I reflect on this aspect of middle age, then, I walk slowly through my apartment. What would a stranger know about me by reading my refrigerator door or by listening to my telephone answering machine? What jewelry do I wear most often, and where did it come from? What profile would emerge from the assorted letters, certificates, pictures, and clippings I've stashed in the bottom file drawer? That old trunk in the attic where I've stored all the odds and ends that I can't use or display but simply can't part with either: What do its contents say about my values and priorities? What knickknacks do I keep on the corner of my desk at work? What certificates and

pictures have I hung on my office "vanity wall?" Who do they say I am?

From the vantage point of middle age, take your own "sentimental journey" through your "space." Explore your own important "stuff," and reach through it to what it says about you.

Let us pray. Spirit of God, bring me the wisdom to look at my values, at the way I spend my resources of time and money, at the way I fill the space in my home and life. Enjoy with me once more the successes and hallmarks I reminisce about, and comfort me through the painful memories and regrets. Help me to look directly at what is there and who I am in the midst of it. And give me the strength to make changes if I need to. Amen.

17

Set in Our Ways

Very truly, I tell you, when you were younger, you used to fasten your own belt and to go wherever you wished. But when you grow old, you will stretch out your hands, and someone else will fasten a belt around you and take you where you do not wish to go. John 21:18

At 41, author Amy Tan relates a turning point in her tumultuous relationship with her mother, whom she felt she had never pleased. When her first novel, *The Joy Luck Club*, burst on the *New York Times* best-seller list at Number 4, her mother said: "Hmm. Number 4. Who is this Number 3? Number 2? Number 1?" She quickly added, "I'm not disappointed you're Number 4; I just think you're so good that you always deserve to be Number 1." "It finally hit me," says her daughter. "I remember being so angry when I was younger, not understanding" (*USA Weekend*, September 10-12, 1993, p. 5). Now she understands!

I recognized that rethinking process, where causes, opinions, grudges I've held for years suddenly look different. Yesterday I shared with a good friend my frustration at not being able to put an old family fracas behind me. As a neutral party, she listened to my account of the episode, then commented, "That's not what I hear in what was said." As I considered her interpretation of the exchange, I was struck by the difference in our understanding. She may be right; my version may not be what was intended. Beyond that, however, our dis-

cussion reminded me once again that I don't stand at the center of the universe. My version is not the only one, nor the best one, nor perhaps even the most accurate one. That realization may come with the turf of middle age. Ironically, younger folk with less experience may be more seriously wed to their limited perspective on the way things are. There were those times in my daughter's teens when my words hadn't made it out of my mouth before I heard "Mom, you don't understand" from hers. As happens, we both have grown older. I have become less dogmatic and she more often asks for my opinion and advice. And is it my imagination, or is her advice to me these days truly more mature and wise? It couldn't be my perspective as well that has changed, could it?

But old habits don't give way easily. More often than not, I am so intent on expressing or justifying myself that I forget to wonder about the other side. Then I remember the refrain of an old mentor, "Did you ask?" I am learning, in middle age, that the insights I gain when I do ask for clarification are generally helpful. I don't get my feelings hurt needlessly, for example. And if an interaction does go toe-to-toe, at least the issues are clear and the communication more straightforward.

Sometimes, even before the old age Jesus refers to in his prediction about John, others' voices carry us where we would rather not go. Amy Tan struggled against her mother's acceptance for a long time before she was able to perceive that it had been there all along. I had become accustomed to feeling like the aggrieved party in the relationship I described to my friend. Undoubtedly, it would be easier in some respects to continue feeling that I was.

By middle age, we know how hard it is to open ourselves to the other side of our stories. Fortunately, by middle age, we have also learned how important that is, as well.

Let us pray. Sometimes, dear God, I am led against my will away from views and interpretations that I have grown attached to. At other times, my quick assumptions close me to the possibilities of wider vision. Give me creative imagination, so that I am open to other views and interpretations. And give me courage to listen to them, even when I suspect they may take me "where I do not wish to go." Amen.

18

Closet of Memories

Every scribe who has been trained for the kingdom is like
the master of a household who brings out of his treasure
what is new and what is old. Matthew 13:52

After a recent surgery, I hired the Busy Bees, a local cleaning
service, to do the housework I couldn't yet handle. On the
scheduled afternoon, I was sitting in the living room waiting
for them when I heard the two women outside: "Apartment
21H? A, B, C . . . Where does H come?" I called out to them,
and as they entered, they explained, "We were trying to re-
member the alphabet. When your kids are grown, you don't
need to remember that any more."

I understood completely. In middle age myself, I've come to
imagine that my memory is like a closet that won't hold all my
clothes at one time. Periodically, I have to move some to the at-
tic, trade some with my sister, or give some to Goodwill.
Sometimes, like that pretty blue scarf I got for Christmas sev-
enteen years ago, they vanish completely and inexplicably. At
other times, I thought I gave them away only to have them ap-
pear at inopportune times, taking me by surprise. I once en-
rolled in a hospital course, "Spanish for Medical Personnel,"
only to realize that every word of the French I learned thirty
years earlier and hadn't used since then came back . . . when-
ever I wanted to say something in Spanish.

Sometimes I have a second thought about the things I once
was glad to forget. Some things I wish I hadn't forgotten.

Growing up, I hated piano lessons. Now in middle age, I got a yen to learn to play the guitar. Snippets of music theory trickle all too slowly back to my awareness as my teacher explains scales, modes, and overtones.

Perhaps middle age is a good time to look through one's closet of memories, particularly for the ones we'd like to use again. The first social worker of one of my children called the other day to see how he is doing. When I told her about my worries about his progress, she reminded me of earlier obstacles he had successfully overcome and which I had forgotten completely. They were important memories to bring to the front of the closet that day.

We store our memories in a variety of places. I've kept a journal for many years, but only lately have I discovered the value of reading back through some of the earlier volumes. It's amazing how much I've forgotten. We have a shelf full of family picture albums, and periodically we look through them, each time enjoying again old friends, vacations, and accomplishments. I find many of my memories hiding in my box of old dress patterns and in my recipe books. My prized barbecue recipe fills the house with the aroma both of authentic Ohio barbecue and of pleasant reminiscences about a fellow teacher who gave it to me. There's the tofu meat loaf recipe that I've never used; the recipe itself was a special gift from a friend who loves me even if I do eat meat. I made up this Simplicity dress pattern in red, and always felt pretty when I wore it. That's a nice feeling to remember these days.

It's a generalization (and perhaps not an accurate one) that older folk tend to dwell in the past, and that the young tend to ignore it. In middle age, perhaps we should allow ourselves at least a glance or more behind. If it's fear of the painful memories that holds us back, the chances are that we will be sur-

prised by the pleasant memories as well. "Every scribe who has been trained for the kingdom. . . ."

Let us pray. God, thank you for your presence throughout the days and years of my life. Be with me in my remembering and forgetting. Make my memories a source of pleasure and wisdom for me, and the sharing of them marked by kindness and graciousness. Amen.

Leaping Middle Age's Stumbling Stones

For [the Lord] will command his angels concerning you
to guard you in all your ways.
On their hands they will bear you up,
so that you will not dash your foot against a stone.

Psalm 91:11,12

Funny. One of the things I'm noticing about middle age is how helpful I'm finding some of my old childhood images. Take guardian angels, for instance. As a child, I relied on that holy card picture of the guardian angel hovering over two small children crossing a footbridge over a rushing stream. That got me through the times I was afraid of the dark or of being home alone.

But if my current image of my guardian angel is similar to the one of my childhood, the "stones" I am borne over are quite different now, in middle age. For instance, developmental psychologists generally think of life review as a task of old age, but I think we do some of that in middle age. Right about now, we find ourselves thinking about our life choices and wondering about adjustments, changes, or recommitments. One of the stones I stumble on is discouragement. We may find that we are generally happy with how we've spent our lives so far. At this juncture, however, we may wonder if

we can finish what we've started. I've seen my older child to adulthood, for example. Can I get my younger son as well on his way? Some days, I don't know. That's when I need my guardian angel for assurance.

Similarly in the work arena. I'm struck by how many of us are tired, looking wearily toward retirement. Ten or twelve or fifteen years seems a long time to be filling a slot or going through the motions. One's work in middle age may no longer require the consuming, driving energy it did earlier, fortunately. Our creativity is quieter, steadier, and our task now may be to find meaning and fulfillment there instead of in flashier productivity.

That stone is suspiciously like the one next to it. I find that thinking ahead has become a way of life for me. No sooner have I put the supper on the table than I'm planning tomorrow's meals. I miss the savoring of the food in my mouth today, in my preoccupation with making out the grocery list for tomorrow. I no longer need childhood reminders to watch where I'm going; the guardian angel of my middle age helps me to watch where I am.

If I have one eye on the future, the other eye is on the past. That alone surely accounts for some of my stumbling. It's not so much dwelling on the distant past that is the problem. I am more inclined to focus on what I said ten minutes ago. Second-guessing myself could become a full-time occupation without a heavenly boost along the path. "Did I say the right thing?" "I wonder if the other parents are this strict?" "Am I asking too much?" "Should I have let him do this on his own?" You get the idea.

One stone that causes me more pain as time goes on is self-sufficiency. Somewhere along the line, I went from learning to be responsible to thinking I alone am responsible for every-

thing. Every family needs at least one member who remembers to restock the glove compartment first-aid kit with Band-Aids; that's the up side. But it hurts when I'm ashamed to need help, or when my friends feel closed out of those parts of my life where I need a listening ear or some chicken soup. Is it my guardian angel who gives me the words, "Please, I need help here," to say until they become more comfortable for me to utter on my own?

I fall over this rock more often than any other: old angers. Now in middle age, I am growing increasingly frustrated with the temptation to scratch the old skinned knees of my psyche until they bleed once more. At those times, I admit that I've done all I can do by myself to dispel my old, pointless grudges and bruised feelings. And then I gratefully remember that I have heavenly help. That in itself enables me to be less intense and finally, to let go of some of those angry memories. Angels' work!

Let us pray. Dear God, you've thought of everything, including the times when we encounter middle-aged versions of childhood's rocky paths. The obstacles and apprehensions are different for us now than they were then, but both the feelings and our need for aid in dealing with them are the same. Thank you for your kindly providence in giving us your angels for protection, comfort, and companionship. Amen.

20

The "Message" of Our Work

Jesus said, "Show me the coin used for the tax." And they brought him a denarius. Then he said to them, "Whose head is this, and whose title?" They answered, "The emperor's." Matthew 22:19–21

To break the monotony of a long Friday business trip, I pulled off the road at a pottery billboard. A smaller sign over the patched shed that housed the kiln identified the shop as belonging to the Cole family. I had discovered that name several years earlier at a local museum that traced the family back to its matriarch. Nell Cole, so the story goes, was the first woman in North Carolina to "throw" pottery. In the 1940s, this was so unusual that farmers from miles around used to stop by just to watch her work. Even after other neighboring potters turned to Art on a Grand Scale, the Coles continued to concentrate on utilitarian dishes and pots. I love their story as much as I enjoy the aquamarine salt glaze so characteristic of their work. That day, I picked up some mugs for gifts. Later, as I wrapped them, I looked for the Cole seal with which the family potters imprint each piece. Something new had been added by the current generation. On the bottom of each cup was a wish or aphorism incised in the red clay next to the date and seal. "Have a good day," said one. "Be sweet," "God bless America," and "Love me tender," read the others.

Middle age is a time for looking at the message on our work. Earlier than that, I suspect that we lack the necessary perspective and realism. Youthful choices of life's work are apt to be colored highly by idealism, convenience, or economics. It's in middle age that for the first time we pause long enough to look at what we're doing with our life, at how we've spent our time and energy to that point, at what we intend to accomplish.

For example, from this vantage place, I can see that the seal on the various types of work I've done has been my concern that social institutions—school, church, health care—respond with care and effectiveness to the actual needs of their clients. A colleague is blessed with the charism of hospitality; wherever he has pastored, people feel welcome, at home, connected, known by name. He agrees with that characterization of himself; he consciously focuses his ministry on that value, and is pleased that this seal shows. My neighbor is supremely compassionate toward her teenage autistic son, but her empathy for his limitations is paralleled by her commitment to preparing him to function as well and as independently as possible. So while she knows she will miss him terribly, she is planning for him to move to a group home soon, where he will learn to function in the kind of supportive environment he will require for the rest of his life. The seal on her work with him is self-sufficiency. Together over the backyard fence, we listen to our younger neighbor share her struggle to find more equity in a marriage she is committed to, one that she has entered with trust and determination.

What is the message incised across the days of your life, on your work?

Let us pray. Thank you, God, for the perspective of mid-

dle age. These days I can see with a longer view and greater clarity than before what I have done thus far with your gifts of life and time and talent. Now I can afford both to look at the smudges and cracks, and to claim the beauty in what you and I have fashioned from the clay of the years. Sustain me with hope and courage when I try to change, and bless me with joy and appreciative friends when I celebrate the life you have given me. Amen.

21

Empty Nests of All Kinds

> [Jesus] saw two other brothers, James son of Zebedee and
> his brother John, in the boat with their father Zebedee,
> mending their nets, and he called them. Immediately they
> left the boat and their father, and followed him.
>
> Matthew 4:21–22

Wait just a darned minute! For centuries, scholars and exegetes
have focused on the generosity and faithfulness of James and
John. We applaud the unquestioning alacrity with which they
responded to a few words of invitation from the Lord, leaving
all to follow him.

Meanwhile, the selfless generosity of their father, left hold-
ing the net, goes unnoticed. Well, we middle-agers are not
about to let that continue. Younger readers who pay any atten-
tion at all to Zebedee may look askance at a figure who might
have joined his sons in following the Lord's call if worldly en-
cumbrances hadn't subverted his values. Other interpreters
may view him as dejected and lonely, his wordless role de-
fined by passive stoicism.

Middle-aged readers understand Zebedee well enough to
know the complexity of the moment and the spectrum of feel-
ings it must have occasioned for him. After all, we ourselves
mourn the "empty nest" with the same vehemence that we re-
joice in "having the house back," as our children move out on
their own, for instance. Granted, in Zebedee's place, I would
have been proud of my sons. I would have taken satisfaction
in their willingness to act on wholesome values, and their ma-
turity and self-confidence in striking out to lead their own

lives. But I would also miss the comfort and security of their daily presence and their assistance in the family work as I grew older.

But such mixed feelings are not new to middle-agers, nor are they limited to parents of young adults. This seems to be a phase of life characterized by many such bittersweet milestones. A friend drops by on his way to visit his mother, newly settled in a nursing home. He is grateful that he has been able to give her the material and emotional support she needs, even into the homestretch of her life. It has been a long race for them both. But the other day, for the first time, she didn't recognize him when he came to visit. His satisfaction is mixed with the grief of losing her, bit by bit.

Ambivalence runs in the other direction as well. I am proud of my teenage son, now as tall as I am and not shy at all about giving me advice on assembling a new backyard grill. It's good advice, I note with surprise and pride. But suddenly, I remember when I could carry him on my hip and when he unquestioningly accepted my advice as gospel. And I am sad that an era is gone forever.

It's unfortunate that Zebedee has been allowed to fade into the scriptural shadow of brighter, more talkative characters. We need him, this patron saint of middle age.

Let us pray. Lord, you missed an opportunity. Now, let us hear the words you might have spoken to Zebedee. We stand with our nets in our hands, and our ears eager for your word. We come to you with our sadness at letting go in various ways of those who have occupied the rooms of our houses and hearts through the years. We listen for your word of affirmation for the care we have given them, and your blessing as they and we move on. Amen.

22

Family Memories—
Going Home Again

An account of the genealogy of Jesus the Messiah, the son
of David, the son of Abraham. Abraham was the father of
Isaac. . . . Matthew 1:1,2

Some time ago, devotees of Bill Keane's cartoon strip, "The
Family Circus," noticed the appearance of a new character, a
kindly grandfather who was evidently fairly recently de-
ceased. One panel showed the character sitting on a cloud with
a group of angels, pointing proudly to his grandchildren play-
ing happily in their yard below. Another frame showed the
children talking with one another about their sense that he was
still a tangible presence in their family, as the grandfather's
outline hovered over the little group. The cartoonist's device of
a shadowy figure lent itself well to the way I'd found myself
thinking about the various ancestors in my family. What used
to be a drive-time preoccupation gathered impetus as my sister
and I have lately begun to compare notes from our recollec-
tions of childhood. We've discovered that, in general, it re-
quires the combined recollections of both of us to arrive at
even an approximate picture of the characters.

For instance, I remember my paternal grandmother as
purse-lipped and severe. My sister, twenty-two months
younger than I, remembers lazy summer afternoons when we
were allowed to walk the mile or so to her second floor apart-
ment. She reminisces about the delicious smell of cakes baking
when we would arrive. Then, my memories teased back to life,

I tell her about the tin-lined icebox and the sign in the window that told the iceman whether our grandmother wanted a half or a quarter of a block of ice that day. She remembers the smell of my father's flannel shirts, and I remember the smell of his cigars. She still has one of those shirts in her closet, and not too long ago, I smoked a cigar in his memory.

It's funny how it takes us both to recreate an adequate image of our childhood. But the evangelists faced the same situation in recreating Jesus' story. Matthew's version of Jesus' family tree was written to situate Jesus at the culmination of the whole of salvation history. Luke works backwards from Joseph in his genealogy of Jesus to emphasize his humanity. Between the two, we arrive at a clearer understanding of who Jesus was than we could gain from either writer alone.

I don't know that my ears were ready to hear a different story than mine much before my middle age, though. Before that, I assumed that my sister and I each viewed our growing up in the same way—my way, of course. It took me by surprise that she had a different set of memories, and that we had different pieces of even those events we experienced together. She remembers with pleasure our last vacation as a family; I remembered most of all my sadness that I would soon be leaving home. She remembers fondly my playing with her when we were small; I regretfully remember our quarrels.

What I am learning now is that one can go home again. In fact, going home in terms of talking about our shared-yet-separate history has been an important part in our new learning about ourselves and about each other. Pierre Teilhard de Chardin saw individual and collective growth and evolution as an upward spiral leading to Christ. We are drawn forward by grace, impeded by anxiety. I think of that image as my sister and I travel together along the road of our memories. We've found a kind of satisfying peace as the shadowy figures looking over our shoulders gradually take clearer shape. We are both aware of the risks of taking a closer look, lest our illu-

sions or our relationship be damaged. Still, we travel on together with each phone call, tape, and letter. By middle age, we know the journey is worth it.

Let us pray. Joseph, Mary, and Jesus, sit down and join us. You of all families know the pleasure and pain of living together. Something draws us these days of middle age to look again at our earlier lives from a new perspective. Strengthen our faith in your presence in our lives together, and help us to trust one another as we retell our stories to one another. Amen.

23

Learning,
Loving Serendipity

Make us realize the shortness of life
that we may gain wisdom of heart. . . .
When morning comes, fill us with your love
And then we shall celebrate all our days.

Psalm 90:12,14

Within the space of a weekend, no less than three of my
friends, all of us in our early 50s, called me to say that they had
begun to take steps to plan for retirement. Never mind that fi-
nancial planners say we should have begun years ago. We
have all been occupied with various forms of avoidance, not to
mention care of our own aging parents and our children's den-
tal braces and college tuition. But now, our children, our
friends, our bodies all witness to the reality that we are grow-
ing older.

It was probably that awareness that led me last year to take
guitar lessons. I have no talent for producing music, but I en-
joy it very much. And I wanted to take some musical skill with
me into retirement. If my childhood experience with piano les-
sons was any indication, allowing myself twelve years to learn
the guitar at this point in my life is probably prudent, perhaps
even wishful thinking. I am blessed with a good teacher, a very
wise twenty-four-year-old who sports a pigtail and earring
and plays everything from cello to bass in jazz and rock bands.

Ben manages to be both honest and affirming with amazing aplomb. He has gently prepared me for the reality that folks in my future retirement community may not immediately gather around to sing when I take out my guitar. Still, he offers the hope that I may have a more promising future as a lounge singer, where I can play one chord, then sing *a cappella* for a long time while I'm hunting for the next chord. While the lessons have added whimsy as well as enjoyment to the present as I doggedly prepare for the future, they have also reminded me that nothing is ever really impossible. In fact, I am constantly amazed at how quickly things become possible once I have made up my mind and declare my intention.

It's not that serendipity is new; it's just that the notion of chance isn't entirely comfortable for one accustomed to careful planning. It's risky to run a career or family on chance, even though daily life consistently challenges our real or imagined sense of control. The payoff for remaining open and flexible is confirmation of the belief that in middle age, whether by chance or by design, anything is possible. Seminaries and universities are filled with students our age who have taken—or made—a mid-life opportunity to change careers. Recent studies in our state reveal that at the same time that younger teachers are leaving classrooms, older professionals from other fields are entering them. The Harley Davidson motorcycle manufacturers point with pride to growing numbers of older riders taking to the road for the first time.

This new energy comes at an opportune time, just when we might be inclined to bracket off some goals, dreams, and whims as no longer possible or prudent "at our age." Society expects us to be more serious, and learning to play the guitar or ride a motorcycle, or change careers is made to sound at least mildly eccentric. Nevertheless, while there is certainly something to be said for letting go of some dreams and putting some disappointments to rest, this is the right time for pursuing the really "outrageous" ones with dedication. Perhaps

that is what the psalmist means by "wisdom of heart," the life perspective that allows us now to dabble a bit, to indulge a whim, to be outrageous, to fritter away some time on anything we may have wanted to do for years. Earlier days are a time for common sense, for careful doling out of one's energies and resources, for planning. But in middle age, when we catch our first close glimpses of "the shortness of life," we begin to look again at the "what ifs," and the risks and dreams we didn't choose earlier.

Let us pray. God, you know that I have generally taken life seriously, planning carefully for the needs of those you've entrusted to me in various ways. Now, season my common sense, the habit of my maturity, with wild dreams and the courage to pursue them—at least a little. Amen.

24

Declining Energy

When the man saw that he could not prevail over Jacob,
he struck his hip at its socket, so that the hip socket was
wrenched as they wrestled . . . Jacob named the place
Peniel, "Because I have seen God face to face, yet my life
has been spared." Genesis 32:26,31

I realize I will not be universally popular for talking out loud
about some of the physical drawbacks of middle age. I've
watched the television commercials ("You're over 50 and
you're still in there kicking!"), and seen the newspaper photos
of the 55-, and 60-, and 85-year-olds running in the Boston
Marathon.

By frankly addressing the subject of decreased energy or the
changing nature of one's stamina I am not affirming the stereo-
type of middle age as a time of encroaching infirmity. Not all
middle-agers feel the need to opt out of the opportunity to
chaperon this year's parish youth ski trip (and sleepless week-
end). Nevertheless, some of us do notice that we are content
with less strenuous activities than we used to be, that we plan
housework or vacations differently. Or even that we relish a
weekend afternoon nap.

That being the case, I've decided to count the blessings of
this facet of middle age. For starters, I've decided to really en-
joy that nap. After work last Friday, I stripped floors, starched
curtains, and ironed linens in preparation for the holidays. By
Saturday afternoon, I couldn't go any further. I opted *not* to be-

moan that I can't do all I used to do in the same time frame, but I *did* opt to relish every second of that nap. It was wonderful.

Second, I've gotten used to the value of simply sitting still, of doing one thing at a time. I've always enjoyed listening to classical music on my Walkman when I'm walking for exercise, and my car radio is habitually tuned to National Public Radio. But I was housebound for six weeks recently, and I discovered how nice it was to listen to the music or to some of the NPR offerings without the huffing and puffing and traffic. This came as a major revelation to one who generally combined watching a favorite TV program with balancing the checkbook, dish washing with overseeing children's homework, riding the parking shuttle with reading the morning newspaper. Even with relaxing hobbies I enjoyed, it was as though I had to squeeze all the "leisure" activities into the limited time available by stacking them together.

Third, I've finally quit trying to do everything myself. Some of the time, anyway. I'm aware that when folks offer to help with a project, I'm more creative about ways to share the work and responsibility, and more open to accepting their offers. I've begun to question my old rule-of-thumb: "It's easier to do it myself." When a Thanksgiving dinner guest asks what she can bring, I'm more apt to take her offer seriously or to hand off some of the chores of preparation, serving, and cleaning up afterwards than I used to be.

Your own list may be much longer. We all come to terms with the physical aspects of our middle-aging process in our own ways. It is here that I think of Jacob, who could aptly be the patron saint of middle age. The head of a household that included two wives, eleven children, and herds of livestock, he was probably no spring rooster when he crossed the ford of

the Jabbok on the fateful night of his struggle with the angel. When dawn arrived without a clear victor, the stranger made a move to break loose and retreat. But Jacob tenaciously persisted, "I will not let you go until you bless me." We persist as well, in our tenacious commitment to finding the meaning—the blessing—in each phase of our life-span. Like Jacob, we walk with various sorts of limps, all reminders that we, too, see God here, face to face.

Let us pray. What a hassle this time is, dear God. And when we think about it, what a blessing it is to slow down, to be called by our bodies to notice things that we didn't have time to count as blessings earlier. Still, there is something of a wrestling match involved. Help me to remember that you are in my corner. Amen.

25

Dealing with the Future

Near the cross of Jesus there stood his mother, his mother's sister, Mary the wife of Clopas, and Mary Magdalene.
John 19:25

A number of years ago when my children were still at home and I was in training as a chaplain and pastoral educator, I went to my supervisor for consultation and advice about my work with a patient. "He is sad about his diagnosis," I related, "but when I asked him about his family, he said he has never had an unhappy moment with them." "And you believed him?" she asked simply.

I remembered that the patient's words had brought tears to my eyes. To be honest, however, my tears were less a matter of empathy with him than envy for the idyllic home and family I envisioned from his story. Now, in middle age, I know the painful, realistic "rest of the story." There is no perfect, pain-free family or life, despite my wish that there were. I've never subscribed to the "No pain, no gain" philosophy, and reject the theory that without the bad times we would never appreciate the good times. I feel certain that I could appreciate the good times completely if I had a lot more practice.

It's only by middle age, I suspect, that we have the mature perspective to be able to admit that there are bad times. That's a necessary prerequisite to learning from them. But before middle age, it is probably too painful to admit that our children aren't the dream people we thought they were at birth, or

75

that the career ladder for us may not go as high as we once so carefully planned, or that some of my spouse's habits will never change, or perhaps that the marriage I once thought was made in heaven may not last through middle age. One of the tasks of adolescence and young adulthood is to dream; one of the tasks of middle age is to learn what to do with the parts of the dream that haven't materialized. Not only doesn't the house have four bathrooms and a pool; the bathroom it does have isn't paid for yet. The children may not have gone to college or married the partners we would have chosen for them. Or if they have, we are beginning to see their flaws and rough edges.

Who could understand this better than Mary? Throughout the gospels, there are hints that her life was not idyllic, what with a strong-minded son who thought nothing of wandering off as a child or of putting his home life in second place behind his work: "Who is my mother? . . . Whoever does the will of my heavenly Father is brother and sister and mother to me" (Matthew 12:48,50). Witnessing his execution, she had no inkling of the resurrection or of the future blossoming of the early church to carry her through the wrenching pain of broken dreams.

Middle age catches us in the same place, sometimes. We don't know how our stories will turn out. We don't yet know if we will retire when and under the same circumstances as we've planned, for instance. Who knows if and when grandchildren will arrive? What will tomorrow hold for our elderly parents? And then—much riskier to look at—what does our own future hold, amid reminders from peers who are beginning to have to deal seriously with health issues?

It strikes me now that I've never seen Mary portrayed as middle-aged or elderly. What an oversight! This is a good

time, sensitized as we are to the reality of middle age, to draw closer to the Mary who has been there already, through menopause, the empty nest, the mid-life course correction, and the dealing with her future.

Let us pray. Mary, one of the most difficult facets of this stage in life is real loneliness. Be with us in the losses of middle age, and free us from our anxiety. Bless us with creativity, and help us to use the gifts of middle age for good. Amen.

Epilogue

An interesting thing happened on my way through this book. Several Christmases ago, a friend gave me a page-a-day calendar, "For Women Who Do Too Much." By February, I was ready to throw in the towel. The aphorisms seemed so scolding. I remember thumbing through the pages with a middle-aged colleague to find one that provided what we thought we needed by way of some affirmation of the journey we had already accomplished and some encouragement for the future. By the time we reached the July pages, I resolved to write my own book, a meditation on middle age that would celebrate our wisdom, our survival, our joy, and our contributions to others. It seemed to me that most of us have already accumulated quite enough guilt and regret, thank you.

Somewhere between the conception of the idea and the actual writing, however, I had a hysterectomy, the fourth in a series of recent surgeries. I had saved the writing of the book for my convalescence, thinking that it would be an enjoyable way to spend the time. When I felt worse than I expected to feel, however, I threw myself into the project with a determination that defied reality and common sense. Subsequently, I had to go back to rewrite those chapters. Ironically, the rewriting coincided with a period when I allowed myself to admit how bad I felt. When I sent the rewritten sections to the editor, I ruefully commented, "I guess I write better with *angst* than

with cheer. "Most writers do," was her rejoinder.

It takes a lot of faith to trust the validity of that philosophy. By middle age, virtually all of us have encountered enough hard times to know that we would rather have the easy ones. It isn't particularly helpful up front to know that we will learn from the pain; we still wouldn't choose it. Nevertheless, it's one of the puzzles of life that holding the pain at arm's length or further away also hinders the growth it may bring with it.

From this vantage point, Psalm 57 is particularly poignant. In one and the same song, the psalmist first cries out to God for refuge and shelter: "Have mercy on me, God. . . .I lie down among the lions hungry for human prey"(vv. 1,5). In the same breath, the psalmist promises steadfast faith and thanksgiving: "I mean to sing and play for you. . . .Your love reaches to the heavens, your faithfulness to the clouds" (vv. 8,11). Those words capture the paradox, both the pleasure and the pain of middle age. Amen.

Of Related Interest...

WomanGifts
Biblical Models for Forming Church
Sister Pamela Smith, SS.C.M.; art by Sister Virginia DeWan, SS.C.M.
Each of the women from Scripture profiled here listened, led and
opened their homes as the church came into being, a role likened to
women still shaping and forming the church today.

ISBN: 0-89622-572-0, 144 pp, $9.95

Womanprayer, Spiritjourney
Judy Esway
The author illustrates how adversities can become stepping stones to
deeper spiritual awareness and greater maturity.

ISBN: 0-89622-326-4, 66 pp, $4.95

Letting Go
Reflections and Prayers for Midlife
Judy Esway
Personal meditations and vignettes that encourage readers to face
middle age "gracefully and with joy."

ISBN: 0-89622-434-1, 88 pp, $5.95

Aging with Joy
Ruth Morrison & Dawn Radtke
Practical, workable and effective ways to take charge of the aging years.
For anyone 50+, for children of aging parents and for anyone who cares
for the aging.

ISBN: 0-89622-360-4, 112 pp, $5.95

Available at religious bookstores or from
TWENTY-THIRD PUBLICATIONS
P.O. Box 180 • Mystic, CT 06355
1-800-321-0411